Blank Arcade 2014

Copyright © 2014
Event curated by Lindsay D. Grace

All rights reserved. This book or any portion thereof may not be reproduced or used in any manner whatsoever without the express written permission of the publisher except for the use of brief quotations in a book review or scholarly journal.

First Printing: Jul 22, 2014

ISBN 978-1-312-37568-0

Digital Games Research

Salt Lake City, Utah, 84092

BlankArcade.CriticalGameplay.com

Blank Arcade 2014
Artists

- Roger Altizer | University of Utah
- Barry Atkins | University of South Wales
- James Earl Cox III
- Anjali Deshmukh
- Josh Fishburn | University of Wisconsin-Whitewater
- Brian Patrick Franklin
 Christopher Wille | Illinois State University
- Lindsay Grace | American University
- Carolyn Jong | Concordia University
- Tina Kalinger | University of Utah
- Deirdra Kiai | University of California Santa Cruz
- Hartmut Koenitz | University of Georgia
- Aaron Oldenburg | University of Baltimore
- Benjamin Poynter
- Jean-Michel Rolland
- SWEAT and the University of Denver
- Adam Trowbridge, Jessica Westbrook | Channel Two
- University of California Santa Cruz Xylem Team

Overview

BLANK ARCADE is an exhibition of creative works at the 2014 DiGRA annual conference. Keeping with the conference theme, submissions were invited for games that fill in the blanks. Artists and researchers were asked to submit works from all edges of ludic creative practice. The 17 selections reflect the best of those submissions. The work selected highlights spaces that are relatively uninhabited by other playful experiences or that simply remind players to play differently.

The exhibit balances physical play with digital play, and its intermediaries. It also seeks to embrace the complex relationship between creative and empirical research. The selected works demonstrate varied creative efforts to fill in the blanks of ludic experience, offering new game play experiences, highlighting spaces that are relatively uninhabited by other playfulness.

This is an international collection, with participating artists from North America and Europe. Visitors can view work produced in the United States, Canada, France and England.

Curate by Lindsay D. Grace

Blank Arcade 2014

Currency
Brian Patrick Franklin, Christopher Wille

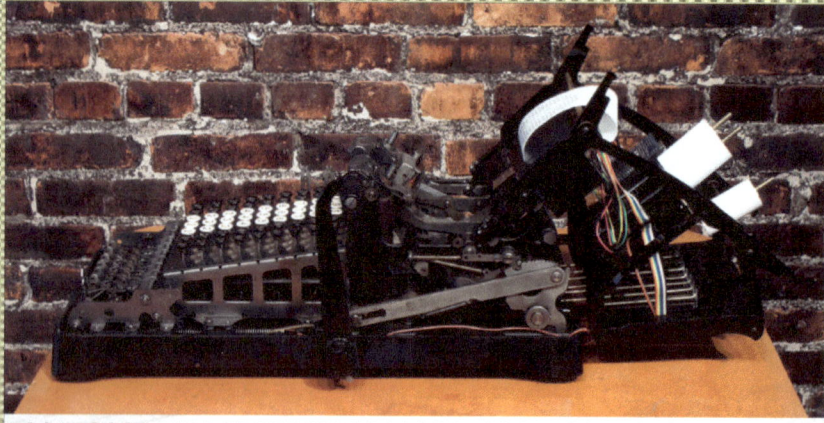

Currency

'Currency' is an electronic game and custom game console that plays with the idea of uncertainty in our actions and the systems we function within. A console constructed from an obsolete Burroughs adding machine monitors the exchange rate of bitcoins to US dollars and uses this data to generate a game level that prints out on a roll of receipt paper. Using the adding machine's grid of numeric buttons, players attempt to pull two columns of abstract ASCII symbols together while being either aided or impeded by the current Bitcoin value.

Players aren't immediately aware of the effects of their actions. It is often not perfectly clear if they have successfully drawn the columns together or have allowed the game to push the columns further apart. Much like the real-time Bitcoin financial data that is driving the game, it is only after looking at the effects of a series of actions does a positive or negative trend become apparent.

The Burroughs machine, with its intricate mechanisms, gives the player a tactile portal into the complex systems that control the movement of bitcoins around the web and across the globe. Similarly, as consumers our understanding of and relationship with currency slips between physical pieces of metal that we can hold and virtual numbers on a screen that exist only in the binary ones and zeros of a computer.

At the conclusion of the game, the roll of paper is torn away and taken by the players, providing a record of their experience and a receipt for their interaction with the game system.

Blank Arcade 2014

The Game of the Game Studies PhD Game
Barry Atkins

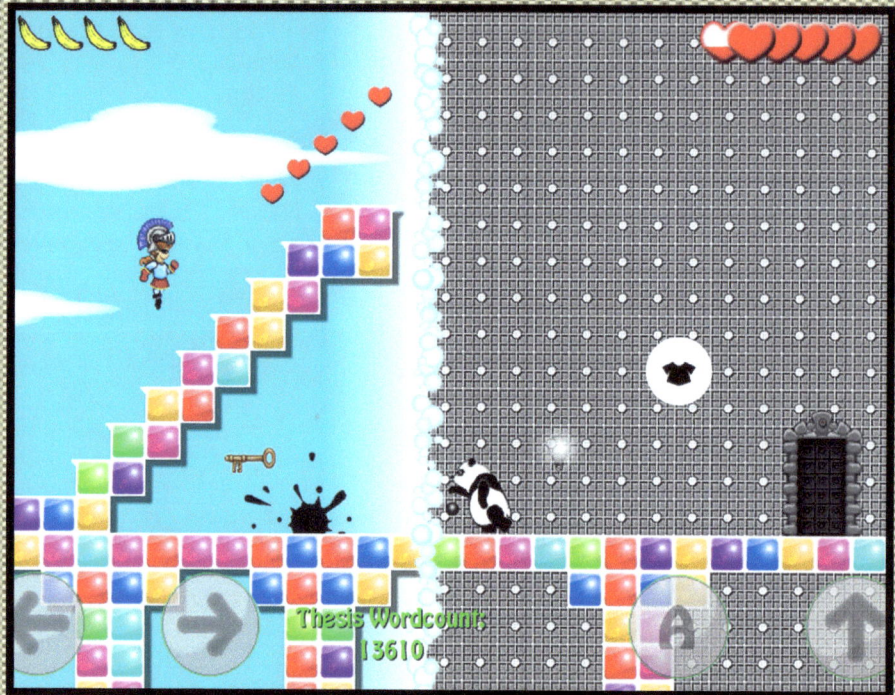

The Game of the Game Studies PhD Game

Developed specifically for the Blank Arcade, The Game of the Game Studies PhD Game is intended to speak directly to the professional and institutional experiences of the DiGRA community, filling in the blank of games about us -- a hitherto underserved constituency among games audiences and consumers, whose most obvious representative to date (academic as game hero) might be Half Life's Dr Gordon Freeman. Given the excitement and peril inherent in daily academic practice it is hard to see why the academic as game hero has been so overlooked, and The Game of the Game Studies PhD Game seeks to provide a simulation of the struggle so many of us have undergone to satisfy the academy and achieve our doctorates, characterizing the long quest to submission of the PhD manuscript as its own hero's journey full of grinding labor, inevitable failures, almost insurmountable obstacles, and all too rare moments of scholarly epiphany. In doing so it stakes a claim to be the most realistic simulation of the process of gaining a Doctorate of any independently produced 2D platform game currently available.

While The Game of the Game Studies PhD is far from a serious game -- and seeks recognition as neither art nor radical intervention in debate -- its deliberate awkwardness and play with dissonance is intended to generate a play experience that itself rewards play. The nature of its play with the expectations and conventions of 2D platform games would make no sense in a commercial project, and instead it celebrates the experimentation with game mechanics that is so characteristic of hobbyist game production. Again and again it plays with expectations of vision within games, concealing and erasing the platforms that make the play landscape and drawing attention back to its surfaces and its mechanics.

This is a game of scholarship, pandas, hats, platforms, robots, interdimensional rips in the space-time continuum, and powerups. And above all else it is a game of affection for its hero – the game studies graduate student.

Blank Arcade 2014

Random [Fortune] Generator Series
Anjali Deshmukh

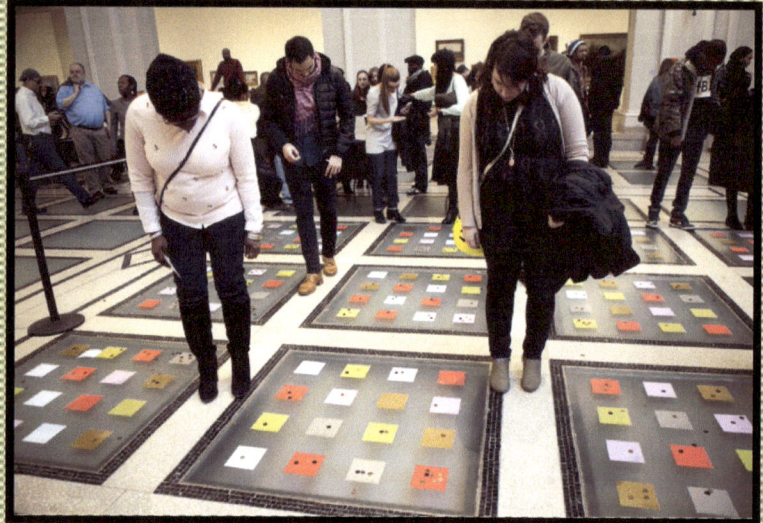

Random [Fortune] Generator]

The *Random Generators* Series is derived from Lila, a word that describes the universe as a cosmic game, the outcome of 'divine' play. Maybe our understanding of this play is an act of passive perception. Maybe it is a story we tell ourselves.

The *Random Generators* play with the modularity of visual and linguistic structures to generate a whirlwind of combinations manifesting experiences of humanity. As a participatory art installation, it produces for and with 'players' a work of visual art that is aesthetically meaningful and creative. It also sparks for players a confrontation with fate or existence and serves as a conduit through which meaningful dialogue can occur between complete strangers. Finally, it is intended to move participants to create something that shifts their thinking or compels them to exercise their creativity in an unexpected -- sometimes uncomfortable -- way.

The 'nervous systems' of the Random Generators are site-specific gameboards on which are written different manifestations of tightly constructed 'events,' ranging from philosophical to psychological, improbable to mundane. These events are part of a growing database of thousands of tightly constructed human experiences. No two gameboards have the same design, and each gameboard is home to multiple games, distinct artworks in the Random Generators series.

Blank Arcade 2014

Renormal
Josh Fishburn

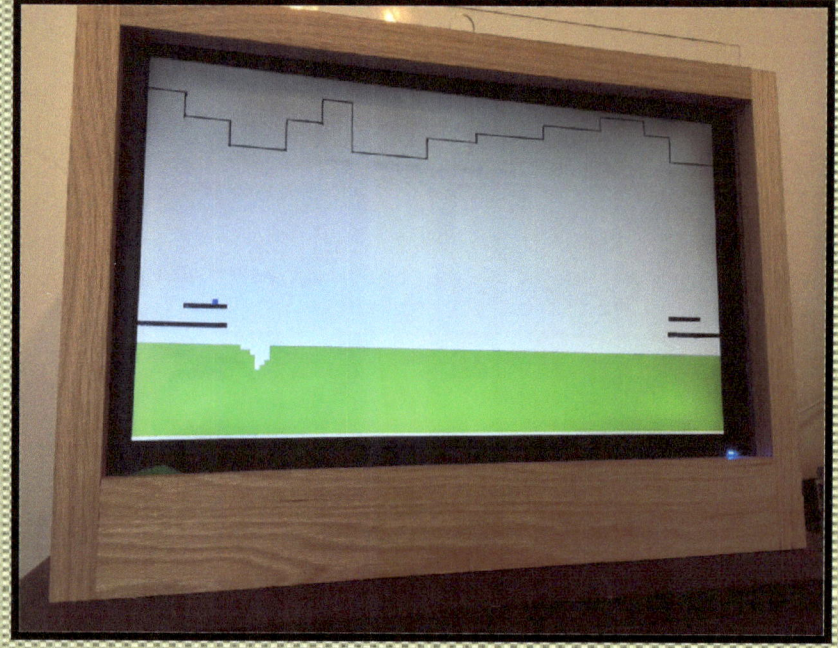

Renormal

ReNormal is a game about rhythm and balance. Its scenarios, which can be manipulated by inserting and removing plastic screens into the game cabinet, are in various stages of imbalance or disarray. They are also interconnected. It is the player's goal to bring them into balance.

I'm inspired by poetically networked games that allow one or more players to peer into a game world from different perspectives, scales, and times. In the past, I have created networked games that explore similar concepts, but I was inspired to experiment with screen overlays when I came across a Magnavox Odyssey commercial that used its television overlays to expand the possible universes offered by its simple graphics. In ReNormal, the screen overlays are an interesting additional interface to the game, and I believe that the manipulation of non-digital objects as part of gameplay can bring about unique experiences.

Blank Arcade 2014

Hertzian Labyrinth
Jean-Michel Rolland

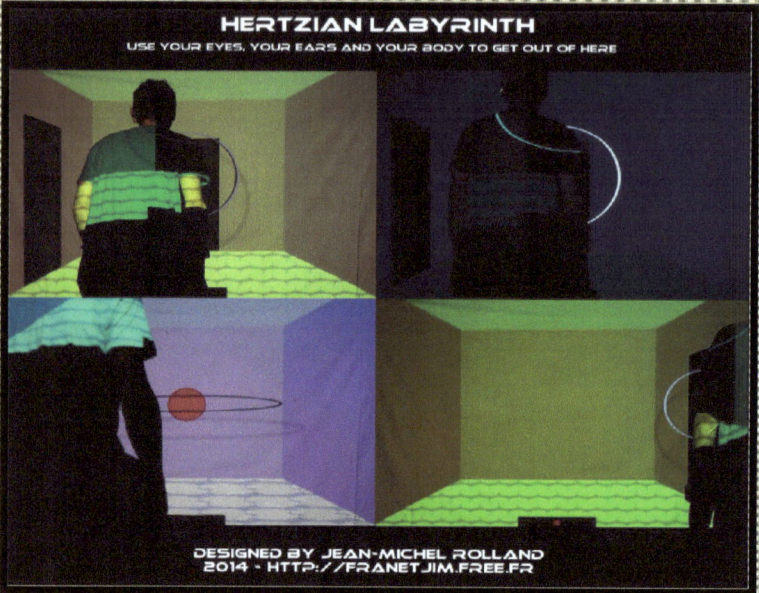

Hertzian Labyrinth

Hertzian Labyrinth can be considered an artistic serious game able to improve the player's listening skills. The player has to escape a series of rooms in which he's locked. The player begins the game in the 150 Hertz frequency room, has to find the key in the 486 Hertz frequency room and go back to the 150 Hertz frequency room to escape. To open the doors, the player has to match his own frequency with the one present in the room where he stands, thus training him to recognize different frequencies and improving his listening skills. The design of the rooms (shape of the carpets, colors of the walls, ceilings and carpets) depend on the frequency of the room.

In the installation, 3 proximity sensors are installed at the bottom of the projection screen, in front of each of the 3 doors. These sensors calculate the distance between the visitors and the screen, modulate the frequencies generated by the visitors and allow the doors to open. Visitors interact with the installation with their bodies.

When a visitor is far away from the proximeter, the frequency generated is low (100 hertz). The closer he goes towards the proximeter (and towards the screen), the higher the frequency becomes (maximum 500 Hertz). The three proximeters are linked to the PC with a MIDI interface directly managed by Processing.

This installation allows a strong collaboration between visitors: It tends to generate collective decisions (visitors have to negotiate the direction to be taken and have to play the game of standing still when they're in front of a door they don't want to open). A visitor who has to lower his frequency, if he has someone behind him, has two possibilities: either going backwards with the risk of shoving, or getting out of the sensor's range in order to let the visitor behind him become the new interactor.

Blank Arcade 2014

Coffee! A Misunderstanding
Artist: Deirdra Kiai

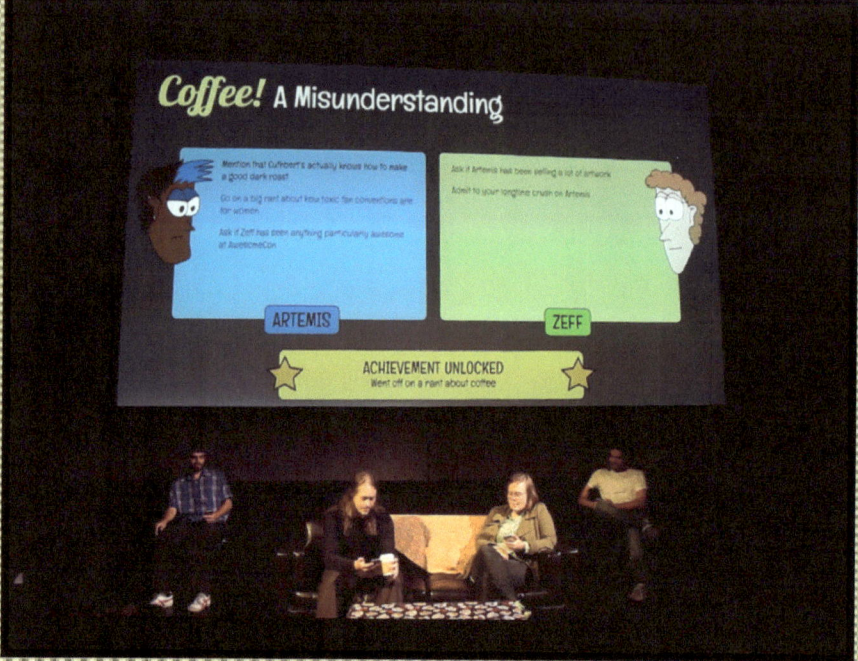

Coffee! A Misunderstanding

A story that kind of looks like your typical "boy meets girl" story at first glance, except the boy doesn't really feel like a boy and the girl doesn't really feel like a girl. A commentary on the weirdness of online friendships that aren't really friendships, set in the midst of a fan convention called AwesomeCon. A play where all the actors are audience members. Maybe one of them will be you? A collaborative game of finding the best ending to the story. Or the worst ending. Or maybe just whatever's the most satisfying. It's really up to you. Anything can happen.

Blank Arcade 2014

You Got Walter Benjamined
Benjamin Poynter

You Got Walter Benjamined

'You Got Walter Benjamined' is an experimental hybrid of a gameplay video, with DDR and BlueMarsLite, and stop motion animation with Google Maps iOS to illustrate the disintegration of 'value' via digital prosthetic and Marxist theory. It is an extension of my own identity as a Japanese-American who has never been to Asia, yet always feels it possible through the mystifying advent of videogames. It takes the ultimate form of an experimental music video, where I replace the existing song with my own at exact BPM. I substitute lyrics with sentences from 'The Work of Art in the Age of Mechanical Reproduction". Per description seen online : The distance between two cities shortens in time. In this experimental music video, it is the lone heart of America and the celestial shores of Japan. Where we live and places we dream about are not so different. The prosthetic potential for achieving destiny presents a sigh of relief and caution. With such haptic interfaces and tools at our disposal, even the most rustic visions of places away become concrete. Tokyo, I'm coming home.

Blank Arcade 2014

Sound Swallower
Aaron Oldenburg

Sound Swallower

Sound Swallower creates a composition based on the real world ambient environment. In this game, your goal is to run and collect fragments of your environment's auditory history before it is erased. Thomas Edison believed that "sounds may linger as elusive auditory ghosts - physical clutter or memory residue that can be accessed by recording technology. . . ." (David Toop, Sinister Resonances). The player records at the location of an abstract sound from the past, and the sound is layered over the recording of the current environment.

The player explores a hidden sonic environment outdoors using their device's GPS and built-in microphone while avoiding the Sound Swallower. This enemy is inspired by Karlheinz Stockhausen's idea of a device that "would be equipped with hidden microphones to pick up sounds on the streets and a computer to analyze the sounds, create negative wave patterns, and return them to cancel out the original sounds" (Kahn, Noise, Water, Meat).

This is from a series of several experiments in audio-based game design that attempt to expand the expressive vocabulary of games, probing what appears to be under-explored territory in audio games: sonic interaction beyond conventional melody and rhythm games. Broader definition of music, such as those proposed by John Cage, have not been widely explored in music-based digital games.

Humans cognitively approach sound in ways that we do not engage with our other senses. Could it be that in games, navigating a 3D spatial tactile world is not the best way to move? How about forward and backward through the time of a sound? What choices could the player make as they move, what obstacles overcome? Studying audio gives game designers new ways to construct (and deconstruct) space and action. Conversely, the 3D spatio-centric worlds of video games give artists who work with audio a space where they can explore goal and conflict-based compositional techniques, giving their audiences the potential to engage and procedurally explore the processes of hearing and listening.

Episodes
Channel TWo: Adam Trowbridge and Jessica Westbrooke

Episodes

Episodes is a multi-level interactive art work in the form of a virtual landfill. The concepts and design are based on site visits to many solid waste landfills in the Eastern and Southern United States, including a 2012 site visit to the WMI Pheasant Run Landfill in Bristol, Wisconsin. At the Pheasant Run landfill we spent the day roaming the property with the site's managing engineer, observing and discussing conventional operations, garbage histories and processing, ecological speculation, and current state and federal regulations. At Pheasant Run we learned that an average environmental policy is in place for 30 years, or the typical professional life of a politician.

Channel TWo New Media Art and Design Studio (CH2) is interested in the ubiquity and implications of built monocultures and landscapes (social, cultural, physical) bulging and buckling under the pressure of capital-oriented ideologies. The complexity and aesthetic beauty of colossal solid waste mountains, and the collaborative chemical magic that flows beneath them are fantastic contradictions: sculpted green abundance in the shape of rolling pastoral playgrounds, floating on an invisible catastrophic core. Episodes was developed as an interactive artwork, but also functions as a 3-dimensional virtual space in perpetual motion. The composition is based upon the concept that visitors to the piece can leave the controller in any location, forming a new perspective on the landscape.

Breaking Points: A life in Circles. And what can change
Hartmut Koenitz

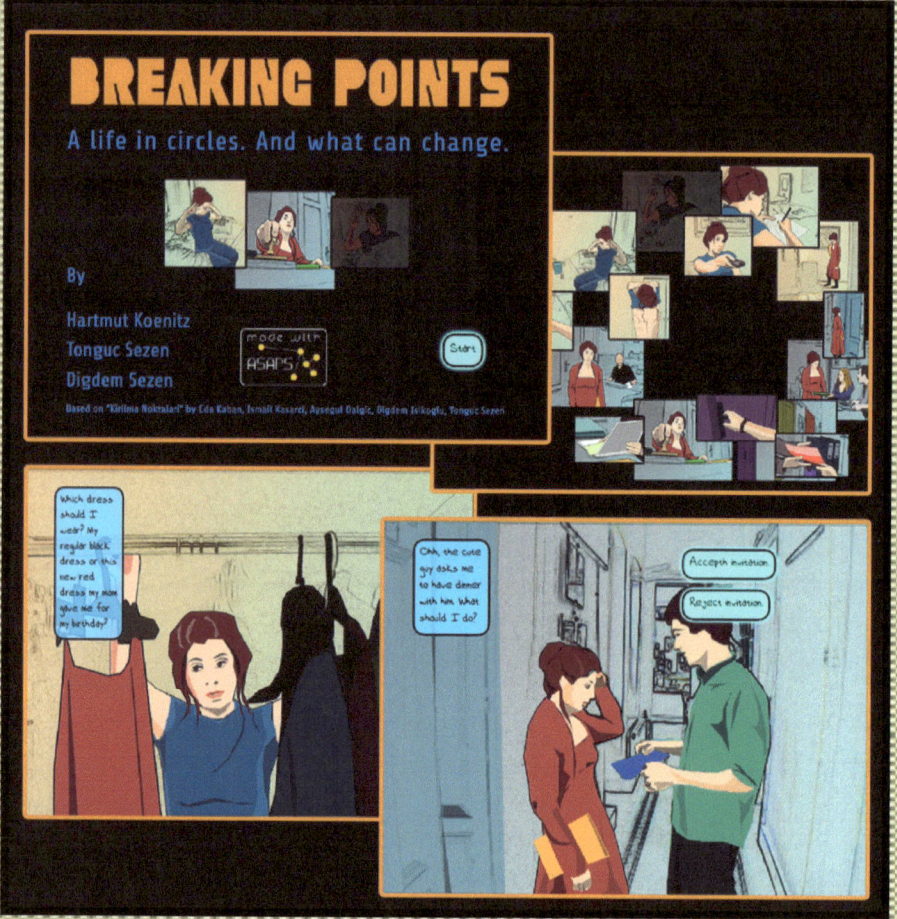

Breaking Points

The drudgery of a daily routine, an existence stuck in a boring, dead-end job, and how to escape from it, but also the issue of perception, the inability of a character to see the small joys and the opportunities offered to her – these are the main topics of Breaking Points. The game explores how small and seemingly unimportant choices impact a character's life as much as decisions we place greater importance on. The related idea of the famous "butterfly effect," that a small insect's movement over the Andes mountain can cause a tornado in far away Florida, is a fruitful basis for experiments in interactive, procedural narrative. A computational system can process many such small choices and select or generate alternate paths accordingly. Replay then allows the user to experience different paths and outcomes. In Breaking Points the notion of repeating and retrying is a key meaning-making element. In its current form, this project is implemented for touch-screen tablets under iOS using the ASAPS authoring tool (http://advancedstories.net).

We applied two main concepts in the narrative design – first, a web of interconnected major and trivial decisions and secondly a balance between immediate and delayed consequences in the form of narrative feedback. We balance interactive, turn-based situations with sequences of screens that present the resulting consequences as narrative feedback in contrast to solutions that apply on-screen elements like progress meters or level-based designs for feedback. In this way, the user makes a series of decisions for the heroine, some of which seem trivial like where to start with the make-up in the morning. Other decisions are expected to be potentially life-changing, for example whether to accept an invitation to a date by a male colleague. While the user will most likely expect the "big" choices to be the major factor for change in the narrative, the narrative design explicitly complicates this expectation. The complicated relationship between decision and outcome attempts to mimic real-life experiences.

Blank Arcade 2014

An Occurence at Owl Creek Bridge
James Earl Cox III

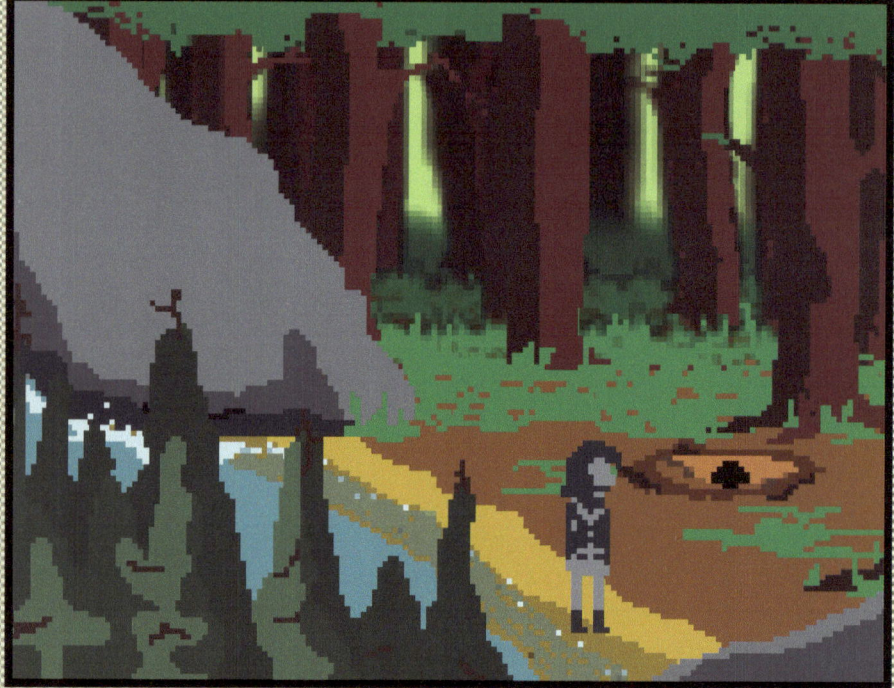

An Occurrence at Owl Creek

An Occurrence at Owl Creek Bridge is a short fiction game by James Earl Cox III. It is a narrative adaptation of the same name Civil War story written by Ambrose Bierce. Besides the title and opening credits, this interactive media tells a story without the use of any in-game dialogue, be it text or audio. As such, the story is conveyed through the use of pixel styled graphics, diegetic sounds, and minimal controls. These allow the player to more freely explore the story, encouraging the use of imagination to interpret the art and build the narrative as they progress, regardless of what language the player speaks. An Occurrence at Owl Creek Bridge is able to move the audience through a deep, historical story within the span of 5 minutes without the use of words as well as provide a portal from gamming to literature; one accessible to people of any age or culture.

Blank Arcade 2014

Capsize
Carolyn Jong

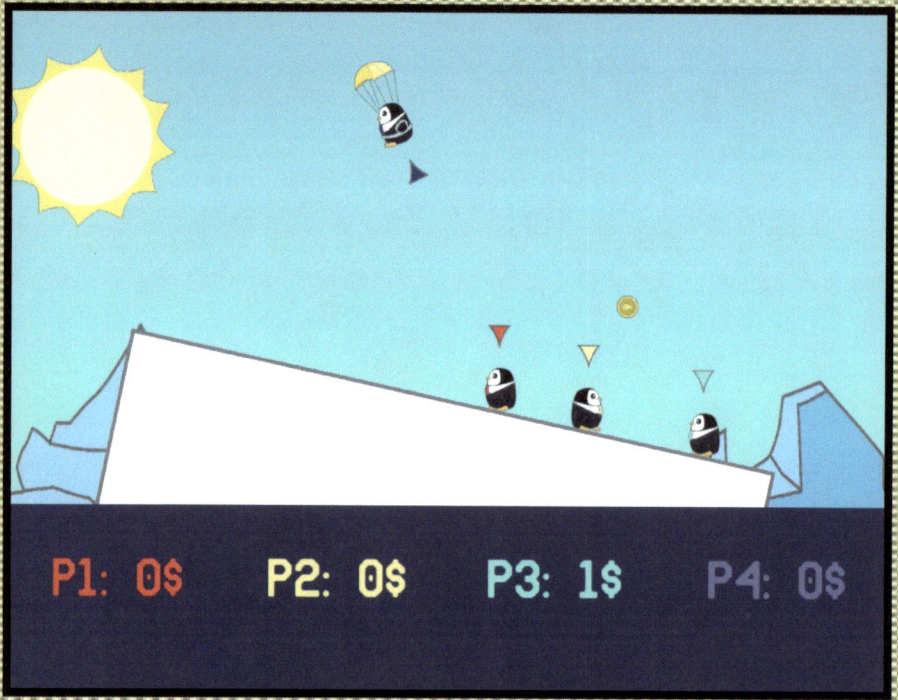

Capsize

Capsize is a playful arcade game with dynamics echoing the crisis of capitalism. It was created by students of the mLab at Concordia University, Montreal, and in the context of the "TOJAM" Toronto Game Jam. It's a local multiplayer arcade game featuring four penguins who seek to acquire wealth while standing atop an unstable and slippery iceberg. As the penguins jump and run from one end of it to the other in their attempts to collect coins, the floating iceberg reacts to the shifts in balance, making the penguins' situation increasingly precarious and eventually, once their greed destabilizes it beyond the point of no-return, sending them all into the icy depths.

Players can decide to approach the game either cooperatively or competitively, as both individual and collective scores are displayed after a game ends. Capsize leaves the question of whether their efforts were successful or not completely open to interpretation by the players.

The game is currently playable on the "Arcade Royale" machine in Montreal, a local community project created by the Mount Royal Game Society. It is accessible and lets player drop in and out of a game in progress at any moment, making it best suited for a highly-social and party-like environment.

PE Game
University of Utah

PE Game

The PE Game fills in the blank between therapy and play. Whereas most medical games are either educational or gamified therapy the PE Game is a true motion controlled "party game" that is therapy. By bringing together game designers and medical practitioners we built a game that bridges the gap between health games and games for health by creating an actual game that is healthy to play.

Blank Arcade 2014

HOMEUnculus
Tina Kalinger

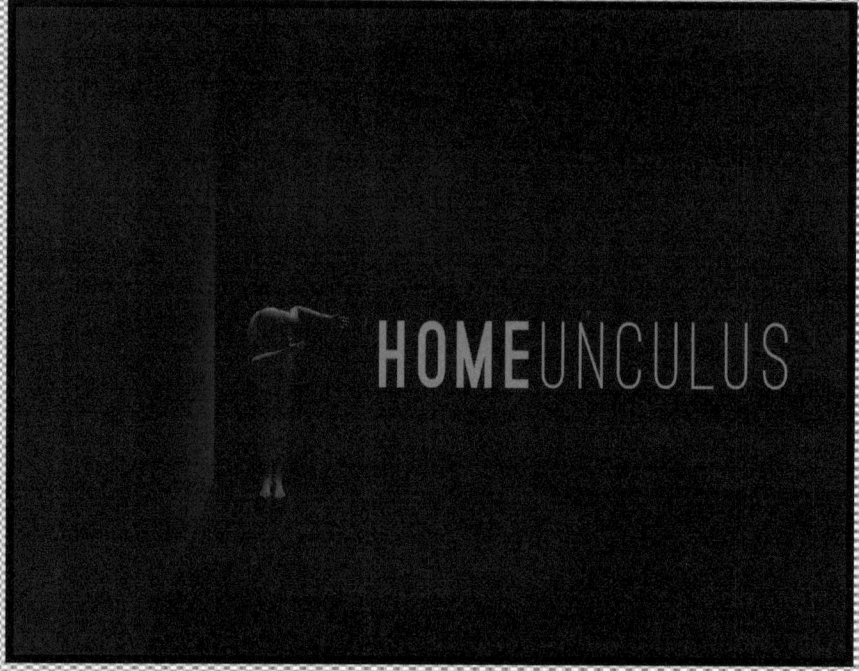

HOMEUnculus

"We don't see things as they are, we see them as we are."

HOMEunculus invites the user to influence the environment by manipulating the bodies that create it – an odd, often absurd reflection of the player/avatar experience. In this prototype, faces cover the walls and floors, while the blank mannequins create obstacles with their body positions. The player manipulates the level using a doll to find solutions to physical puzzles.

When the player moves the doll to clear a path or create a staircase, all of the mannequins in the level move, creating new puzzles and challenges that are never the same for each playthrough. This mannequin movement not only acts as the primary puzzle solving mechanic, but also contributes heavily to the uneasy atmosphere of HOMEunculus. The unnatural movement and positions of the mannequins get under the skin, without jump scares, gore, or atmospheric scares beyond soft background music. HOMEunculus is an experiment in gameplay and body horror, one we hope to further explore with additional levels and body mechanics.

Sow / Reap
SWEAT: Andre Blyth, Esteban Fajardo, Teri Galvez, Tommy Hoffman, and Ben Lehr

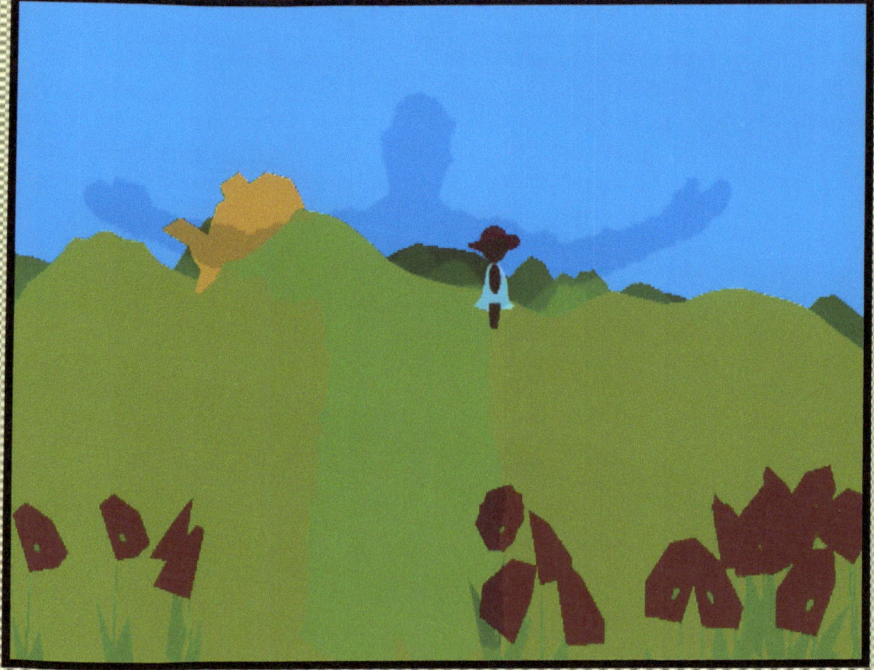

Sow / Reap

Sow/Reap is a big, "physical," multiplayer, game-like experience of sowing and cutting down poppies. Sow/Reap comments on the War on Drugs through the game play. Sow/Reap offers a space for the participatory creation of landscapes. It is big in that it requires a large space (20' x 20' x 10') for the minimum installation of three overlapping, networked, play spaces. Sow/Reap is scalable up from this minimum installation. The players interact with Sow/Reap striking a T pose, one that quickly increases the width of the bounding box surrounding their data shadow. The players presence in the game world is signaled back to them through the display of this data shadow captured by a Kinect sensor.

Sow/Reap was created by SWEAT 3.0, the third version of a collaborative dedicated to making socially conscious videogames. We did not overcome any hardships to make this game. We had the privilege of time and the luxury of space and equipment with which to imagine and prototype a large-scale installation. We had the support of colleagues and families to explore. We took these advantages seriously and have tried to make something worthwhile at the intersection of Art and Games. We've tried to craft an experience that can be appreciated in a short amount of time, and that will resonate in participants minds for a large amount of time.

SWEAT is a loose collaborative dedicated to the creation of socially conscious videogames. This iteration is comprised of Andre Blyth, Esteban Fajardo, Teri Galvez, Tommy Hoffman, and Ben Lehr. It is directed by Rafael Fajardo.

SWEAT gathered to work on Sow/Reap during the summer months of 2013, borrowing space from the University of Denver (DU). Teri worked on the visual art; Andre, Esteban, Tommy, and Ben worked on game design and code; and, Rafael behaved as creative director and producer.

Blank Arcade 2014

Xylem: The Code of Plants
USCS Xylem Team

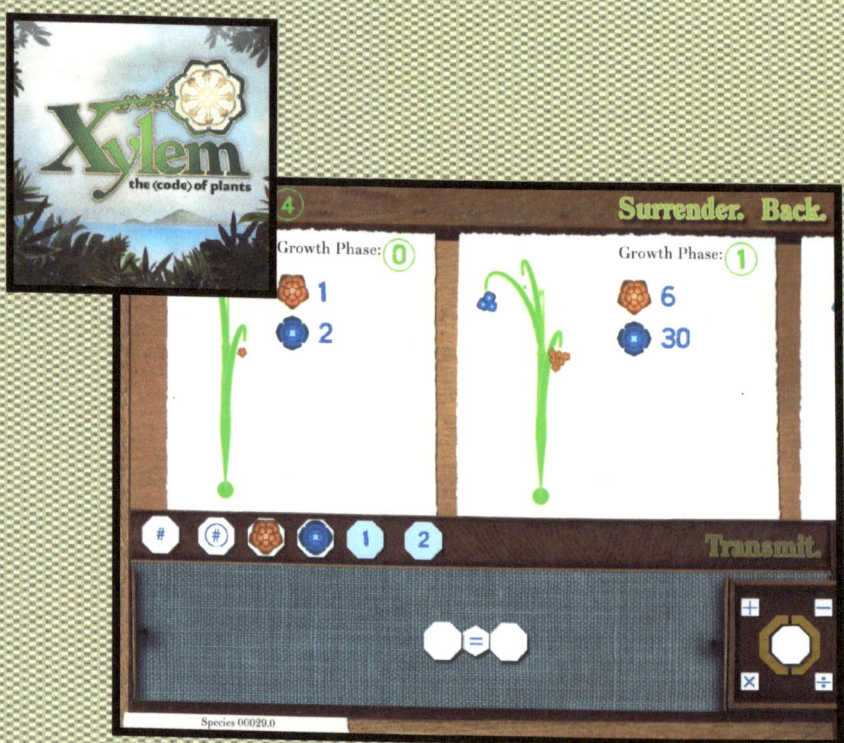

Xylem: The Code of Plants

Xylem: The Code of Plants is a quasi-casual math puzzle game with the goal of crowdsourcing formal software verification through the analysis of loop invariants. The game presents players with puzzles derived from data produced by loops in a particular piece of software. Solving these puzzles involves finding and expressing a loop invariant that holds for that set of data, which results in an annotation in the original code. In this way, players can contribute to the effort to formally verify a piece of software while enjoying mathematical puzzles.

Taking on the role of a botanist in 1921, the player catalogs new plant species by describing patterns in the plants' morphology. While players solve puzzles and find patterns in fictional plants, they are simultaneously helping with real-world software security. As players solve puzzles, they are simultaneously providing loop invariants which in turn prove small pieces of the target software to be correct and free of possible common vulnerabilities. With many players contributing, the cost of doing formal verification is reduced by shifting work from highly-paid experts. This frees up these formal verification experts to focus on the harder, more interesting, problems or to prioritize the efforts of game players.

In order to find a loop invariant, players must first examine the different growth phases of a given plant species by comparing samples (growth phases) of that species side by side. The player's job is to discover one mathematical rule that holds across every growth phase of that plant. Once the player has intuited a solution that holds true for each growth phase, their task is to construct a mathematical equation that describes the pattern. The player is provided with a set of tool tiles that can be dragged into a central workspace and linked together to form these equations. If the created rule holds for a given growth phase, the background of the "slide" representing that growth phase turns green. The player has a successful solution when all slide backgrounds for a species turn green

You, a Very Meaningful Game
Lindsay Grace

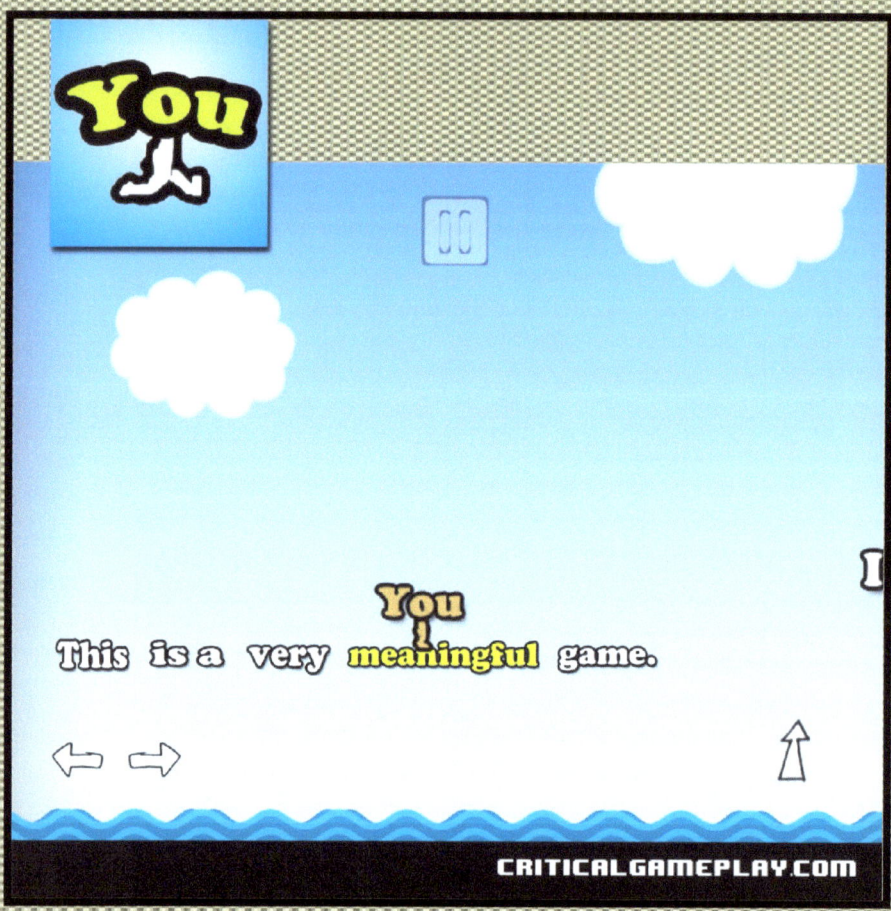

You, a Very Meaningful Game

You, a Very Meaningful Game, is about play and the illusive pursuit of meaningful play. Each level of the game is requires players to problem solve a space for You to meet objectives while making sense of the in-game content. Using the player character You, the player is both making meaning out of nonsense and finding meaning where it is absent. The game is designed as a light-hearted critical reflection on the intersection of narratology and ludology. Players must play with You, I and Them in the immutable structure of meaning making that forms the challenge of the game.

Borrowing from the rhetoric of research on narrative, play and the illusive pursuit of meaningful play, the game takes as its subject You. A character who is backwards, if not traveling forward. A character that moves playfully, although permanently bound to the awkward limitations of its unmasked pursuit of meaning and place.

The player must put You in its place, filling in one of many blanks. At times, the player must manage You and I in simultaneous concert, in opposition or in cooperation.

The game is organized around the notion of a game poem. The game is not designed as a serious experience, but instead as a critical experience in meaning making in play. It is the 10th game in the Critical Gameplay collection, a 5 year project to offer alternative ways to play.

www.ingramcontent.com/pod-product-compliance
Lightning Source LLC
Chambersburg PA
CBHW041114180526
45172CB00001B/252